The YOUR BOOK Series

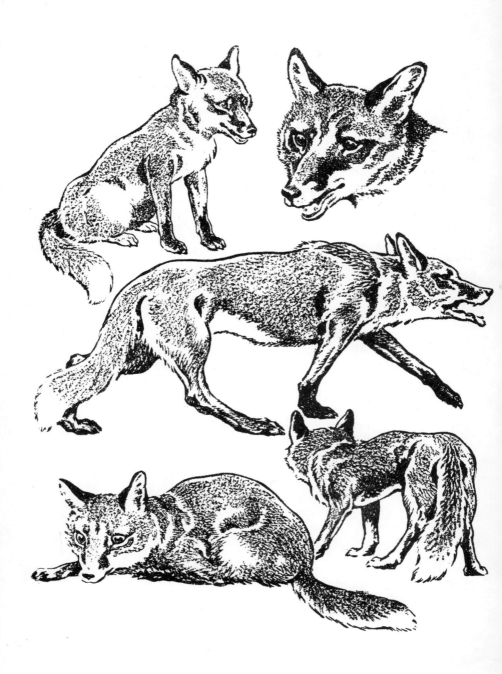

YOUR BOOK OF
ANIMAL DRAWING

Written and Illustrated by

CYRIL COWELL

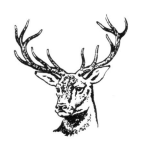

FABER AND FABER LIMITED

3 Queen Square London

First published in 1955
by Faber and Faber Limited
3 Queen Square London W.c.1
Second edition 1962
Reprinted 1968 and 1975
Printed in Great Britain
by Unwin Brothers Limited
The Gresham Press, Old Woking, Surrey

ISBN 0 571 05139 1

CONTENTS

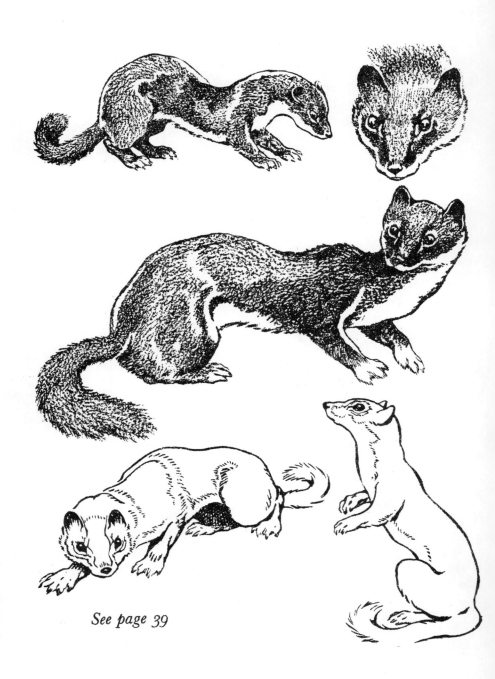

See page 39

INTRODUCTION

My own introduction to an enthusiasm for animal drawing began during my schooldays, when at times I kept a number of creatures of various kinds. These pets were frequently used as models for my sketch-book.

One I remember was a charming little dormouse. He was named Moses because he was found near some bulrushes. Although he soon became quite tame he never lost his natural wanderlust, and on several occasions he was retrieved from a spree among other boys' lockers.

While making a sketch of him one evening my bedtime came all too soon, for at that moment Moses leaped to the ground and before I could recapture him he had scrambled up my leg. With one hand clutching him beneath my trousers, and in the other holding a small cage in which to transfer him later, he retired with me to the dormitory.

While at this boarding-school one of my 'heroes' was the late J. A. Shepherd, famous for his wonderful humorous animal and bird drawings. He lived several miles from the school, but such was my admiration for his work, the distance did not deter me from walking to his home one day, only to find he was away.

After I had been privileged to spend some time in his studio I began my long return journey to the school. There was very little traffic on the road at that period, and as I tramped along rather wearily I began to realize I should arrive long after the time I was due back. To my relief an empty funeral hearse, drawn by a pair of handsome black horses, approached. I 'thumbed' a lift, but my worry was not over, for the progress was very slow and as I sat by the ancient driver he explained that horses such as these were only allowed to go at a jogtrot pace. So I arrived late after all, but the punishment I received was well worth the experience of seeing the studio of such a master of animal sketching.

Other visits to Mr. Shepherd's home followed and I have always been grateful for his kindly advice. Some of the tips he gave me will be found in this book.

PREFACE TO THE SECOND EDITION

In addition to the hints on drawing British wild animals this enlarged edition includes further instructions and helpful material on the making of sketches of domestic and farm animals.

TRACKING YOUR QUARRY

Nearly everybody likes watching animals, some enjoy doing so more than others. If that interest leads you to making a keen study of their habits in the open air the knowledge gained will certainly be a help to you when drawing them. By watching wild creatures in their natural surroundings many points about them will be photographed on your mind, enabling you to remember their movements and poses more easily. Make mental notes of the positions of their legs while they are at rest; when they are walking, running or jumping; the twist and general carriage of their bodies; the turn of the head, and so on.

To do this you must go to the country-side, into the woods and fields, over the commons and by the waterside, always taking pencils and a sketching-book with you.

Animals of the wild do not intend you to see them 'at home' in their own surroundings. The secret of successful nature hunting' is, therefore, to go about your job in silence; to have infinite patience and to be able to keep perfectly still and quiet. If you bear this in mind, and are prepared to lie down or crouch in a cramped position, you can watch the creatures of the wild at close quarters. You may see rabbits feeding, a weasel stalking its prey, or even fox cubs or young otters at play. These, and a host of others, are sights you will never forget.

9

On these occasions you will find that a pair of field-glasses are a wonderful help.

You will probably have little chance of making careful sketches of animals under these circumstances when you do see them, for they are constantly on the move. Don't worry about that; they certainly won't keep still for very long—that is *your* job—that and the rapid notes you must make on your paper of their varied attitudes.

Be content with many swiftly executed, but unfinished, impressions rather than one or two unsatisfactory attempts at trying to make a finished drawing while you are out animal stalking.

These lightning sketches will teach you more about animal characteristics, and will result in your gaining more knowledge, than any amount of laboured drawing; that part of your work can be done at home. It is then, when you are doing studies full of detail, that you will find the benefit of your rough notes.

MUSEUM AND ZOO

Although so much knowledge of your subject can be gained in the way already described, you cannot, of course, hope to see clearly in the woods and fields exact details of features, such as the formation of paws, with the correct number of claws on any particular kind of animal; but

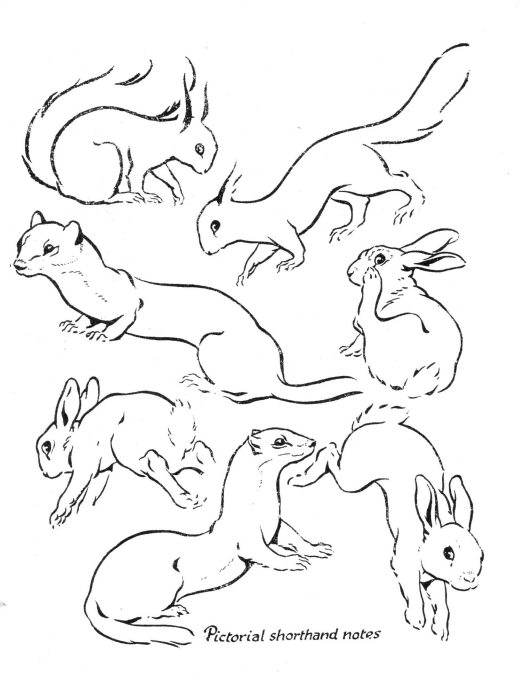

Pictorial shorthand notes

correctness in all such peculiarities is necessary when doing the finished drawings.

Perhaps you have access to a museum in which there is a collection of British mammals. If so, go there as often as possible. Many a pleasant and profitable hour can be spent studying the exhibits and making quick studies of them on every occasion. These, however, are frequently so placed in cases against a wall as to prevent you from getting an all-round view of the specimens. If this be so a request to the curator for any particular animal to be taken from the case so that you may make studies of it from different angles will generally be willingly granted if it is possible to move it.

Stuffed specimens of animals may not be perfectly true to life, but they are of great help to you when you wish to study details at close quarters.

Maybe you are fortunate enough to be within reach of a zoo. In that case take every opportunity of going there. In a zoo, the animals are confined to a comparatively small space, and you can get first-hand knowledge of some which are seldom seen in their wild state.

Supposing, then, you are fortunate in having a good model in front of you; take the opportunity of making careful, detailed studies of the eyes, ears and legs.

Note the direction of the lay of the fur on each part of the body, and, of course, do some drawings of the complete animal from all positions.

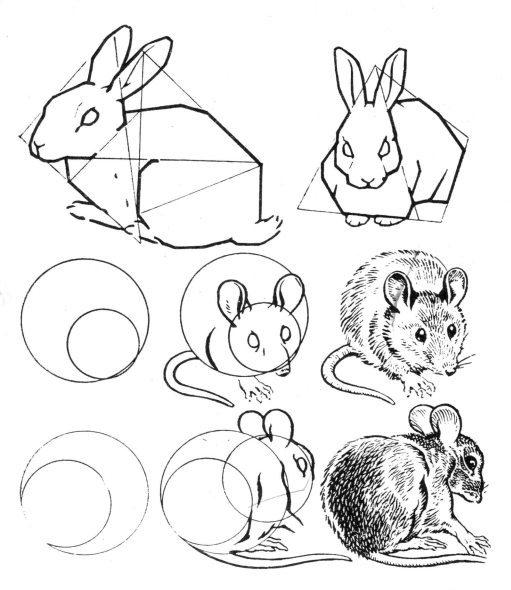

Sometimes it is helpful to base your drawing on geometrical shapes, building up the general appearance of the animal upon these, and finally filling in the details.

Don't be discouraged by unsatisfactory results; every fresh sketch you make will teach you something. Very few artists are completely satisfied with their work. Satisfaction spells stagnation. Improvement will come as practice progresses.

MATERIALS

Choose the materials you will need for your sketching carefully.

The pencils should not be too hard or too soft. Try a B. 2B, Hardmuth's Negro No. 2, Wolff's Black Solid Ink, or Conte Crayon.

Sometimes it is an advantage to sharpen the pencil to a flat chisel shape or to a long point. By holding the pencil under the hand, laying the point nearly flat on the paper, and using your wrist more than your fingers, you can get both broad and fine strokes.

Practise over and over again, making bold decided lines, both curved and straight, heavy and light, with the aim of obtaining complete confidence in handling the pencil. Avoid doing timid, hesitating strokes which reveal an uncertainty of your subject.

With the pencils named I think you will find you can obtain all the necessary effects of animal form, features and fur.

The paper of your sketching-book should not be too rough. I prefer cartridge or thin bank paper. When using the latter I sometimes place a part of an old book cover, having a suitably grained surface, under the page in use. The grain should be neither too fine nor too coarse. The impression of the grain allows the pencil to produce interesting results and to obtain quick effects, especially when depicting the shading and texture of an animal's coat.

You should seldom need to use rubber during the making of rough sketches. While many of the preliminary lines may not be as you intended, they are better left. By frequent rubbing out you will not only lose time, but also that spur-of-the-moment effect your sketches should have.

Mediums to use other than pencil are charcoal, pen, brush and waterproof ink. Charcoal is a delightful medium; to prevent smudging, it must be 'fixed' by using a sprayer and liquid sold for the purpose. For pen and ink drawings try Gillott's 290 and 659, a crow-quill. With these two pens you should be able to produce all the effects needed to make satisfactory line drawings of animals; there are many others and by trying several you will find the pen or pens which suit your particular style as it develops. I would, however, advise you not to be in too great a hurry to do pen drawings of animals; try to attain proficiency in pencil sketching first.

Pen drawings for reproducing tend to reveal any weaknesses or faults you may have, which, in pencil work are

more easily corrected. Very pleasing effects can be produced with a brush and black waterproof ink in place of, or in conjunction with, a pen. By using the ink fairly dry on the brush the texture and shading of animals' fur can be satisfactorily suggested.

With practice the essential lines denoting the movement and expression of an animal can be rendered by a few deft strokes of the brush, resulting in a drawing full of life and animation.

Whether you intend your drawings of British animals to lead to something more than a pastime or not, the pleasure of every walk through our lovely country-side will be doubled by the pictorial memories of wild life with which you return; provided, of course, you don't leave your pencil and note-book at home.

LIGHTS AND SHADOWS

When you are drawing any animal remember that it has three dimensions, height, width and breadth or thickness. To make sure the animal in your drawing appears convincing bear this in mind all the time, so that the effect of light, half-tone and shadow on its body gives it a natural shape and character. This can only be achieved with constant practice.

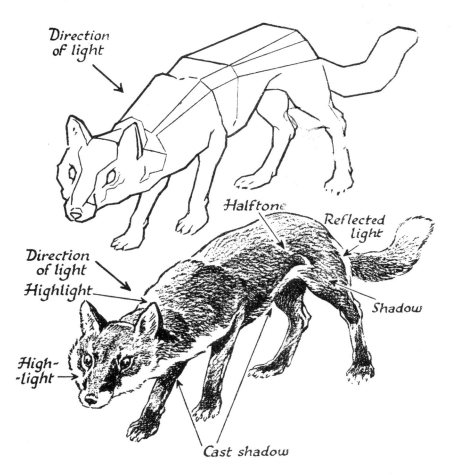

Direction
of light

Halftone

Reflected
light

Direction
of light
Highlight

Shadow

High-
-light

Cast shadow

It is because of the effect which light has on the solid sur-
faces of any object—in our case an animal—that we get the
appearance of the solidity of its form. Look for the brightest
parts, those which catch the full light. Then notice the parts
or areas which are turned away from the light; they are
seen to be in half-tones.

In addition to these half-tone planes there will be seen areas in shadow, some being deeper in tone than others. Within the shadows you will notice parts that show reflected light. These variations of light and shadow on the surfaces of different parts of the animal's body, if placed correctly, help to make your drawing true to nature.

Suppose you are making a drawing of a fox. In order to understand the facts about light and shadow more clearly draw the animal in such a way that it appears to have been crudely carved from a block of wood and to be composed of flat planes—then imagine the light to be coming from any one direction—the light falling on those flat surfaces at right angles to the direction from which the light is coming appears lightest. The further the other planes are turned away from the source of light, the deeper in tone or shadow they will be, except where they are affected by reflected light. The drawings on page 17 should help to make this clear.

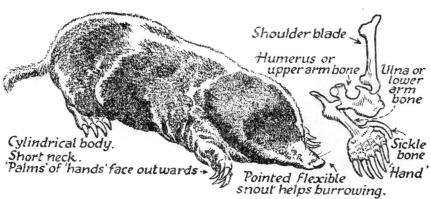

Shoulder blade

Humerus or upper arm bone

Ulna or lower arm bone

Sickle bone

'Hand'

Cylindrical body.
Short neck.
'Palms' of 'hands' face outwards →

Pointed flexible snout helps burrowing.

EXPRESSION

Just as human beings display emotions such as fear and joy, so animals, by the pose of their bodies and their facial expressions, exhibit a surprising variety of feelings. The stealthy artfulness of the fox and the inquisitiveness of the squirrel are examples. Other emotions which you may notice in different animals are alertness, fear, determination, defiance, playfulness and, of course, anger.

Try to catch these expressions and attitudes in the animals as you make your sketches.

The light in the eye; the pricking or depression of the ears; the attitude of the limbs; the turn of the paws and feet; the hang of the tail and the twist of the mouth; all these are worth noticing, for each varies, and each is an indication of an animal's feelings at the moment and together they form a picture of his general character.

THE MOLE

The streamlined body of the little 'gentleman in velvet', as the mole is often called, is admirably adapted to his mode of underground life. His pointed snout and shovel-shaped 'hands', with a sickle-bone and five 'fingers', each terminating in a sharp claw, help him to tunnel his way

below ground with wonderful rapidity; in fact his mode of progress has been called subterranean swimming. It is in the forepart of his muscular body that his extraordinary burrowing powers lie; the latter half terminates in a short tail for which he appears to have little need.

His tiny pin-head eye and his ears are so well hidden among the vertically growing velvety fur that they are difficult to find. The pile of the fur lies forward or backward, according to the direction in which he is moving below the soil, and this prevents his soft coat from becoming begrimed.

Your best chance of studying the mole is in May or June when the breeding season keeps them more active than at any other season.

THE OTTER

The otter's body is long and agile, with a thick tapering tail. His head is broad and flat. His smooth pelt is so closely matted that his skin always remains dry even after long spells of swimming. His short powerful legs have large feet, five-toed and webbed and the strong tail is used as a rudder. All these features make him admirably adapted to swimming and diving. When under water the otter's movements are almost fish-like as he twists and turns in graceful

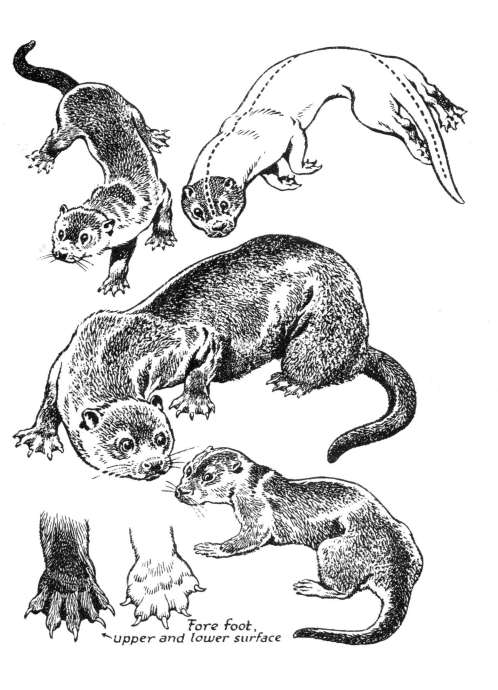

Fore foot,
upper and lower surface

curves, aided by his webbed feet, long lashing tail and the strong muscles of his back. The dotted line in the preliminary sketch marks an imaginary line along the centre of the body. In making drawings of such animals in movement this unseen line is useful as a guide to the placing of the main curve of the body.

When walking by the banks of a stream you may come across some five-toed footprints on which the marks of the webbing of the foot can be traced. These are made by an otter and are known as otter spurs. His home, called a 'holt' is sure to be nearby.

Mention has been made of otters at play. This often takes the form of romping down the steep banks along the riverside.

The ground here is worn smooth and slippery by constant use and in winter these tracks, when covered with snow, become regular toboganning sites; the whole family of otters taking part in the game.

You would be lucky indeed to witness, from cover, so extraordinary a sight as the parent otters actually playing with their youngsters in the twilight.

THE WATER VOLE

Unlike some British animals who are active mostly at night, the water vole or water rat can be seen at any time of the day along the banks of a brook or river, sitting on his haunches, holding a piece of water-flag or a mass of duckweed in his forepaws. He munches the tit-bit in much the same way as a squirrel will eat a nut.

The general colour of his back is reddish-brown and yellowish grey below, not at all like his namesake the brown or black rat except in size; in fact he is quite a handsome animal. The length of his head and body is about eight and a quarter inches with a tail about half this length.

His burrow is usually in the bank alongside the water. His diet includes aquatic plants as well as the bark of trees, and at times he will raid the farmer's root vegetables, but apart from this fault he is a harmless creature.

Although his feet are not webbed like the otter's he can swim quite well. His eyes and ears are small, his muzzle blunt and his legs short. His body is corpulent and less shapely than some other rodents.

Watch him as he paddles towards the bank of the stream. See him climb on to the anchored platform of water weeds he has constructed. Note how he drags the tasty morsel of iris he has brought with him; then, squatting on his home-

made dining-table, you will see him proceed to nibble the juicy stem, cast away the unwanted parts and, with an almost silent 'plop', dive into the water, swim away half submerged, to return later with another succulent meal and repeat the performance.

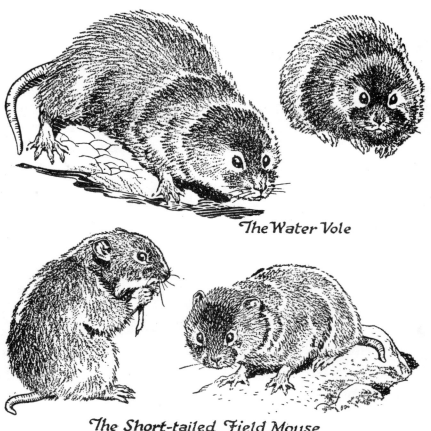

The Water Vole

The Short-tailed Field Mouse

THE SHORT-TAILED FIELD MOUSE

The short-tailed field mouse is somewhat similar to the water vole, but its size is about the same as an ordinary mouse and the tail is only one-third the length of the body. The colour of its fur is greyish-brown above with a lighter tone below. It is most active at night, but you may often see it during the day in the fields where it constructs long burrows beneath the grass which hardly moves at all as the mouse, with snake-like movements, glides among the blades.

The nest, composed of a ball of moss and leaves, is hidden away among the grass roots.

This mouse, or field vole, causes much damage by eating seed-corn in the furrows and nibbling the bark of trees until they are completely 'ringed'.

Compared with the long-tailed field mouse the expression of his face is sheepish. Notice his small rounded ears, blunt snout and sunken eyes.

THE LONG-TAILED FIELD MOUSE

The long-tailed field mouse is a true mouse and not a vole. He is a beautiful little creature, rather larger than the short-tailed field mouse, and with a more pointed muzzle.

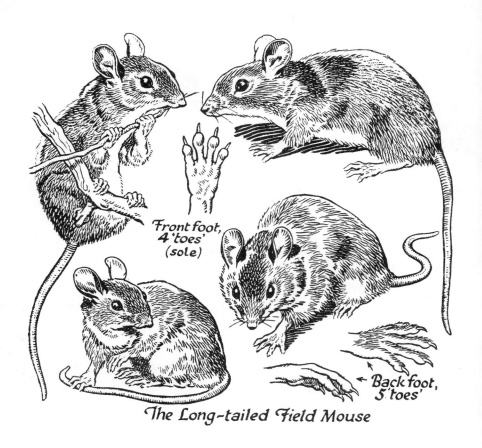

Front foot, 4 'toes' (sole)

Back foot, 5 'toes'

The Long-tailed Field Mouse

The fur is a reddish-grey above, merging into light brown on the chest and white below. His large appealing eyes, big pinkish ears, long tail and shapely body give him a charming appearance. You may find him in the hedgerows and in the garden.

26

He is an active little fellow, full of energy and constantly on the alert. His prominent eyes give him a wide range of vision, and by flattening his ears he is able to look behind him with hardly a movement of the head. These ears, being large, give him a very keen sense of hearing. His paws and feet are adapted for grasping almost as well as human hands.

With these advantages and his athletic movements he is difficult to watch, but, with perfect quiet and stillness on your part, you may be lucky in catching glimpses of him while he is 'washing' himself or busy feeding. Mark well his home and then wait for him to appear, which he is sure to do sooner or later; and when he does you will certainly feel that the period of waiting has been worth enduring. You may see his protruding eyes staring at you, but, provided you remain motionless, this will not deter him from performing his toilet. The little paws, moistened by his tongue, will give his face and ears a thorough cleansing. This will be followed by a hind leg being clasped and washed to his satisfaction before the other leg is treated similarly.

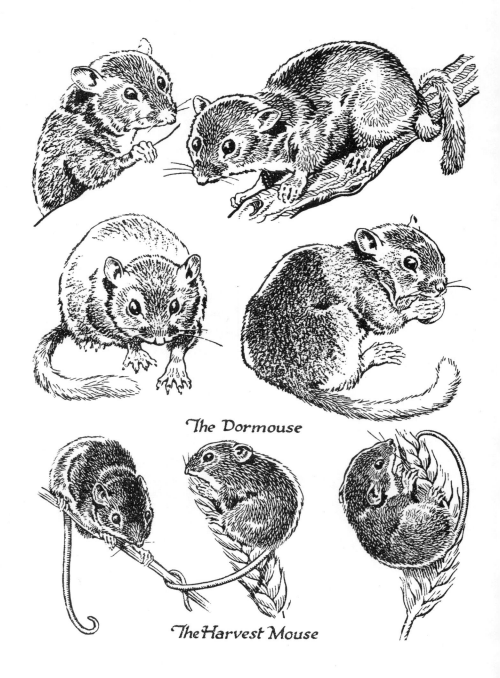

The Dormouse

The Harvest Mouse

THE DORMOUSE

Of the several kinds of mice found in this country perhaps the prettiest is the dormouse. He resembles a miniature squirrel rather than a mouse, both in appearance and to a certain extent in his habits. The way he uses his bushy tail as a parachute when leaping and the flattening of his sides during the jump are very like the squirrel's methods. His large projecting eyes give him a great range of vision similar to that of the long-tailed field mouse.

You are not likely to come across a dormouse between the end of October and April; during that period he will be tucked up in a snug ball within his neat winter quarters fast asleep.

If you find a number of nutshells with clean circular holes gnawed from them you may be sure they are the remains of a dormouse's meal, and that you are within his territory. Other mice and squirrels go at a nut in a more haphazard fashion, often splitting the shell. He appears to have very short legs and arms, but their full length is concealed by his fur and the folds of his skin. He makes a charming pet but resents too much handling.

He may be found sleeping during the daytime. At dusk, however, he awakes to full activity, swinging from bough to bough or darting in and out among brambles or bracken with such speed that he is difficult to follow.

THE HARVEST MOUSE

Some kinds of mice are most active at twilight but the tiny harvest mouse loves the daylight and is a keen sun-bather. Even so, he is a difficult creature to study because he lives mostly among the cornstalks well away from the edges of the fields. He is a remarkable gymnast, and performs the most wonderful gyrations and revolutions, spinning around at a giddy angle while clinging to a stalk with the aid of his toes and using his tail as a means of support. He is about two and a half inches long, with yellowish-red fur above, and white below.

In your drawings of mice try to catch the alertness they so constantly display. Both mischief and caution seem to radiate from their beady eyes. Make a point of producing the suggestion of the fluffy furriness of their coats.

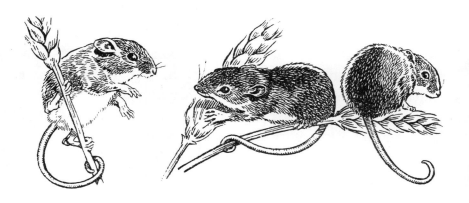

THE COMMON OR HOUSE MOUSE

One might think that opportunities for sketching the common or house mouse would be more favourable than those afforded by other wild creatures, but he is just as active as other kinds and very elusive. He is able to spring quite a distance and a vertical wall is no barrier to him, for his power of climbing enables him to overcome any such obstacles.

The difficulties of making drawings of these and other small rodents are made much easier if they are temporarily confined in a cage.

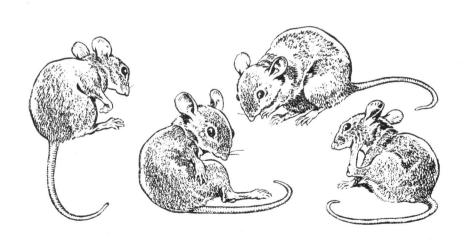

THE SHREW MICE

As distinct from the short blunt nose of the harvest mouse that of the shrew mouse is long and extends well beyond the mouth. There are three kinds of shrew mice, the water shrew, the common shrew, and the pigmy shrew, who has the distinction of being the smallest of all our British animals. They have a cluster of bristles encircling their snouts. The fur on each of the shrews is softer even than that of the mole.

Owing to their incessant restlessness, except while under cover, the shrews are difficult subjects for pictorial study.

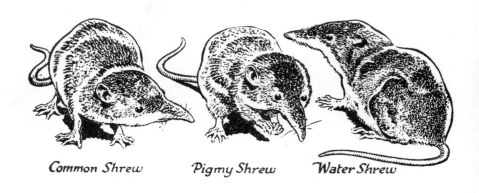

Common Shrew Pigmy Shrew Water Shrew

THE SQUIRREL

There are two kinds of squirrels in this country, the red and the grey. The red is now scarcer than the alien grey and is perhaps the most beautiful of all our woodland creatures.

The red squirrel is perhaps the more likely to be seen in coniferous woods, among the larch and pine trees, but the grey squirrel can be found among deciduous—leaf-losing— trees and seems to prefer beech woods to any other kind.

Apart from colour differences the red squirrel has long tufted ears and sharper features. In the autumn the ears lose these tufts, the coat is shorter and the colour of the tail becomes lighter. The forelegs are much shorter than the hind legs in each case. The feet and paws are long and well suited to his needs when clinging to branches as he flits from one to another several feet away.

If he loses his balance he alights similarly to a cat; the legs are wide spread, the tail and the loose skin over the ribs are flattened out to break his fall. As he sits on his haunches holding a nut in his forepaws, which he uses almost as we use our hands, his plume-like tail is curved over his back, but when climbing or running it is outstretched. Strive to depict the nimbleness of his movements in your drawings and the unbounded curiosity displayed in his features.

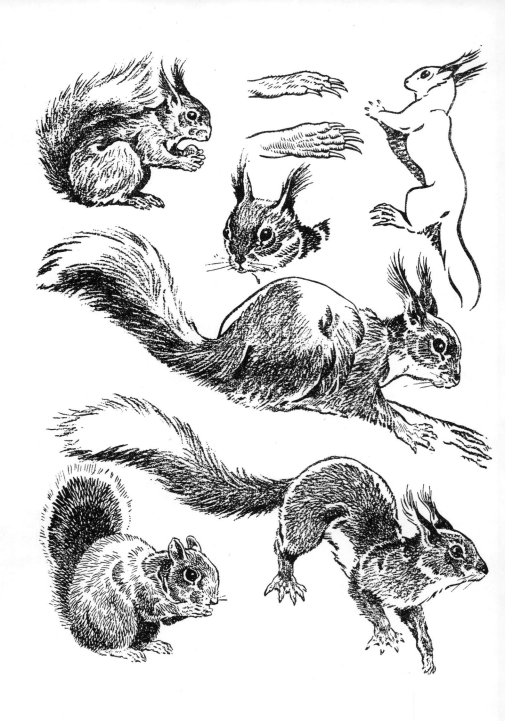

When on the ground and danger threatens he will climb a few feet up and around the safer side of a tree, holding his body close against it. If you remain still you may soon see his feathery ears and keen eyes appear cautiously round the tree watching for your next move. Make mental snapshots of his lightning antics and get them on to your paper in simplified form before the impression fades.

THE FOX

The main points which strike you when watching a fox are his stealthy movements, his alert attitude and the sly expression of his eyes. Features to note are his long low reddish-brown body, the underside of which is paler. This lighter-coloured fur continues along the underside of his neck and lower jaw, where it is broken by a patch of darker fur extending downwards from his muzzle. This seems to accentuate his cunning appearance. His head is broad and flat, tapering to a sharp muzzle. His ears, usually held pricked up, are tipped with black as are the forepart of his feet and lower part of his legs. When near exhaustion point the fatigue he is feeling is shown by the body almost touching ground, the hanging tongue and flattened ears.

The fox will often set up home in an 'earth' previously used by a badger or in an enlarged rabbit's burrow. If the peculiar odour which Reynard emits is noticed near either

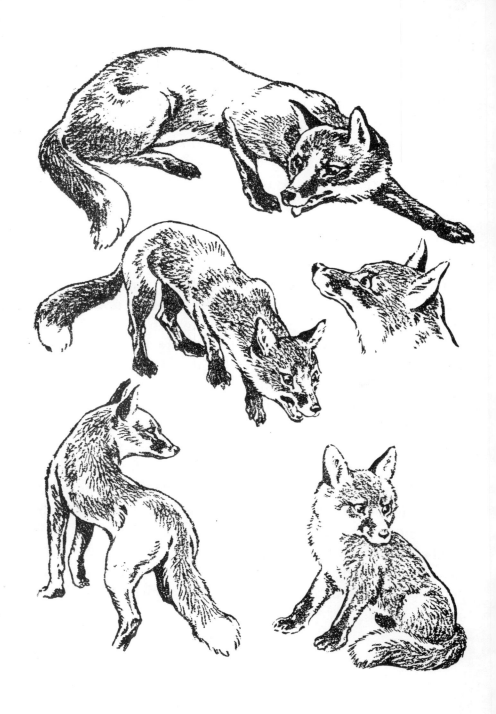

you may be sure it is a foxes' lair. Then, if a 'hide' is made a short distance away, there will be a good chance of seeing both parents and their cubs.

THE RABBIT AND HARE

On a summer evening rabbits can be studied feeding, chasing each other in circles, jumping over one another, and stopping every few moments to perform their toilet. Both in and out of the burrow the rabbit's life is fraught with threats of danger. Perhaps, for this reason he seems always to wear a suspicious or startled look. On scenting danger he stamps on the ground with his hind feet. It is then you will see those rabbits within earshot scurry away to safety, their white tails showing conspicuously.

The hare is larger than the rabbit. His ears are longer than his head. The eyes are very prominent and set near the ears, enabling him to see behind him when running. He can leap up five feet at a bound or five yards forward. The hind legs are nearly double the length of the forelegs; these powerful limbs help him to move with great speed. The forefeet have five toes, the hind feet have four.

Take momentary keen glances at rabbits and hares in various positions, jotting them down in 'pictorial shorthand' as quickly as possible.

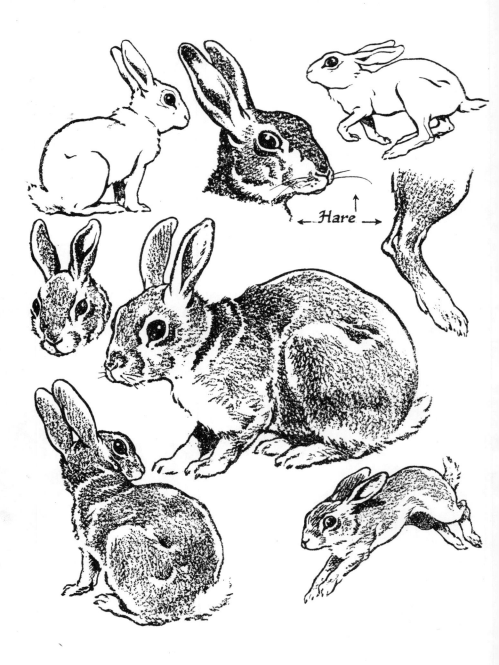

Hare

THE STOAT AND WEASEL

Stoats and weasels are comparatively common. They both have reddish-brown hair. They are similar, but the stoat is the larger, being about fourteen inches long. A third of this length is taken up by his long bushy tail, at the end of which is a black tip. Weasels are darker in colour, about ten inches long, with a short tail which has no black tip. Points to notice are their tiny narrow eyes set in a flat snake-like head, the sensitive nose, a white underside to the long thin body, and their short legs.

When out hunting the weasel's swiftly moving sleek form is straight at one moment and well arched the next. His nose is held to the ground because of his dependence on his sense of smell rather than sight.

Stoats and weasels can stand erect, climb trees and swim, during which the head, neck and shoulders are all held high out of the water and the back is curved.

They are ruthless hunters and, once on the trail, they never give up until their victim has been tracked down. Try to get these characteristics emphasized in your sketches.

Illustration on page 6

THE HEDGEHOG

The hedgehog gets the latter half of his name from his pig-like snout. He feeds on slugs, snails, worms and many kinds of insects. His back is covered with prickles or spines which he can raise or lower at will, and when danger threatens his means of defence is to roll himself into a ball, the sharp 'spines' sticking out in all directions. Fully grown, he measures about nine inches. He has bright protruding eyes and his legs are so short that his body seems to touch the ground as he walks. His feet have five clawed toes. He is frequently found in woods and hedgerows.

If one is caught young and fed on raw meat, bread and milk in the first place, he will very soon adapt himself to his surroundings in the garden, where he will make himself useful by keeping down the insect pests and give you opportunities for sketching him. Provide him with a large box in which a clean bed of dry leaves, moss and grass is made, and he will not stray away from his new garden home.

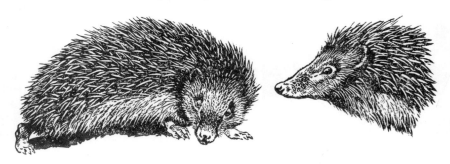

THE BADGER

The badger is less likely to be seen than most British mammals owing to his nocturnal habits. He does not often emerge from his 'sett' or 'earth' in daylight; however, you never know your luck.

Points to note are the pronounced black and white markings on his face, his greyish fur, broad stout body, pointed head, ears that lie flat against his fur, and his long sharp-clawed feet, the soles of which are bare. These are very useful to him when making his 'sett' or 'earth', collecting dry bracken for bedding and in foraging in the woods. His home usually has a wide opening under a dry bank near tree roots.

On the bark of trees near by the 'sett' you may see claw marks where the mother badger has been teaching her

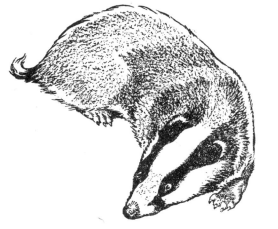
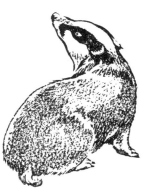

youngsters to sharpen their claws; and possibly you may find a few grey or black hairs clinging to nearby twigs.

Other signs indicating the site of the badgers' home are trodden paths leading away from the hole—one of these usually ends in a little arena, cleared and secluded; this is the baby badgers' playground.

DEER

The largest wild animal to be found in this country is the deer, of which there are three species: the magnificent **Red** deer which may be seen on Exmoor in Somerset and in the Scottish Highlands; the Fallow deer, the dark brown kind and the spotted kind, both smaller than the Red deer; and the smallest species, the Roe deer.

You may find each of these kinds in parks in various parts of the country. In order to approach deer to within a distance near enough to make your sketches you must come upon them upwind to prevent their getting a scent of you. This applies to many other creatures of the wild, most of which have a wonderfully developed sense of smell.

Only the male deer carry antlers; those of the Red differ from the Fallow. The Red deer has a long 'beam' with a number of points or tines, while the Fallow has two tines

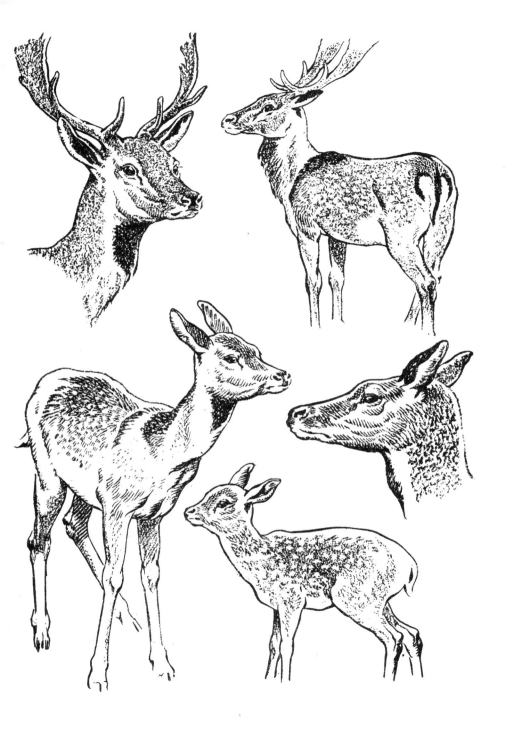

on each side, but the upper part develops into a broad shovel shape edged with small points.

If you go to one of the big public deer parks such as Richmond in Surrey during May and June you may see some of the young deer or fawns. They make excellent subjects for animal studies. Their large trustful eyes, long ears and graceful shapes, with dappled white spots along their flanks, combine to make them the most delicately built models of all British wild animals.

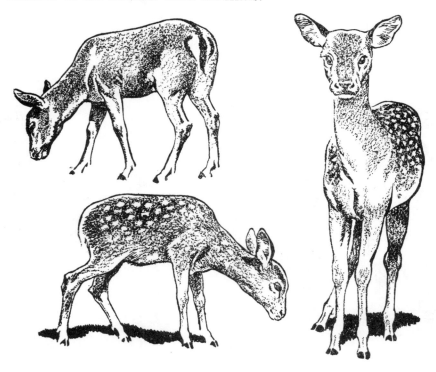

STRUCTURE

Before attempting the sketching of any animal you will find it a great help if you have some knowledge of its structure.

By studying the diagrams of the skeletons of various animals shown on these pages and noting the differences in their anatomy you should get a better idea of their form when making your drawings.

Make notes of the way the bones are formed and placed. Try to get a mental picture of the positions the bones take when the animal is at rest, walking or running.

These diagrams will help you to visualize the underlying framework of the animal in action.

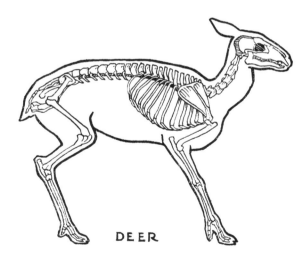

DEER

RABBIT

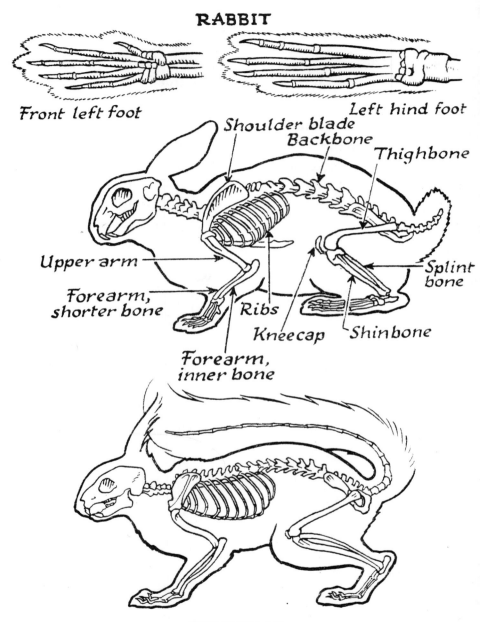

Front left foot

Left hind foot

Shoulder blade
Backbone
Thighbone

Upper arm

Forearm,
shorter bone

Ribs

Kneecap

Shinbone

Splint
bone

Forearm,
inner bone

SQUIRREL

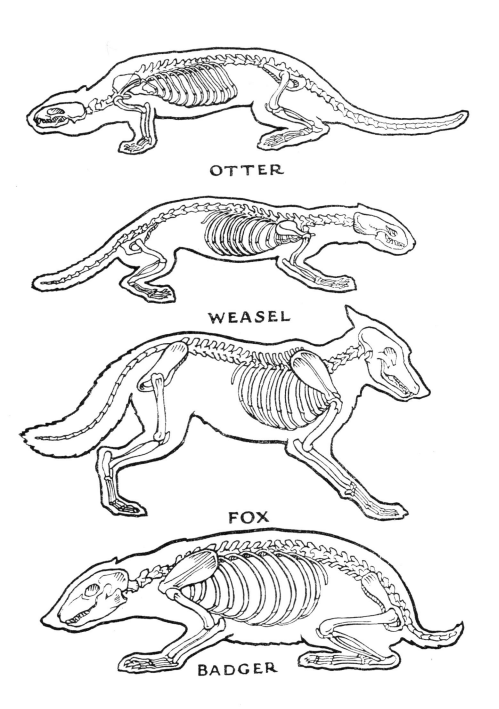

OTTER

WEASEL

FOX

BADGER

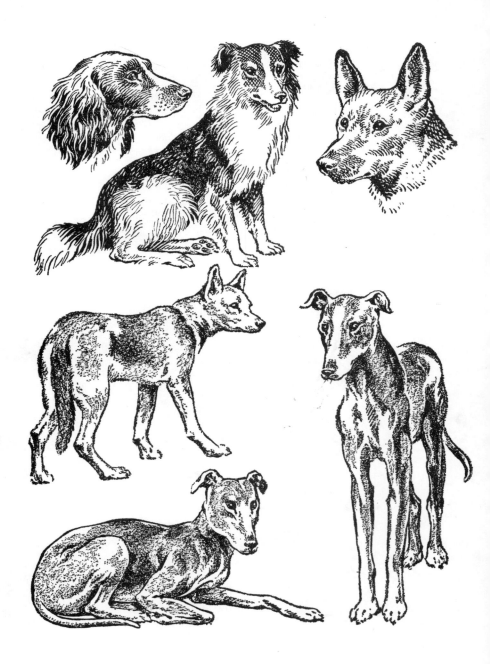

THE DOG

You may sometimes find it impossible to reach the haunts of the wild animals of the countryside. This need not prevent you from making sketches of other animals. Perhaps you or your friends are dog owners; if so, take every opportunity of getting pictorial notes of them. Every dog will provide you with the chance of continuing the fascinating hobby of drawing animals. Gain the confidence of a dog with which you have had no previous acquaintance by talking to him quietly before attempting to do any sketching. Dogs vary in character, but most of them respond to a gentle approach. It is impossible to make successful drawings of a restless dog. Once your model has become calm, start sketching rapidly, noting his outstanding points, proportions and general form. Having secured a rough idea of your subject, go for the details and important features. It is better to make several unfinished studies of the eyes, limbs and other parts before attempting a complete drawing.

THE CAT

Try to catch every pose and movement of all kinds of cats, making quick rough notes. Study the cat's general shape and actions when walking, feeding, turning and crouching. The sketches you do will help you to attain greater assurance, so that when making finished drawings you will have far greater confidence than you previously had. Try to suggest the softness of the animal's fur, its direction of growth and the markings on the body.

Kittens are, of course, far more lively than their parents; consequently it is more difficult to make successful drawings of them. Sometimes it is worth while catching a fleeting glimpse of a kitten in playful action, and then immediately closing your eyes and concentrating hard on the pose before jotting down a pictorial impression of the kitten's movement. The opportunity to visit a cat or dog show should not be missed. Many pages of your sketchbook will be filled by the time you have made notes of the various models on view.

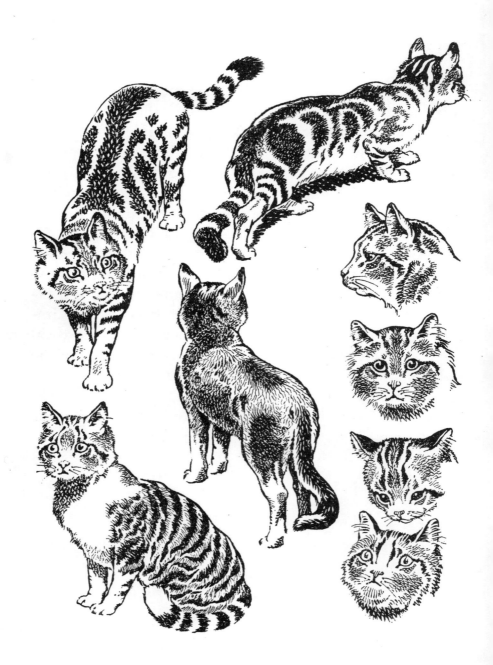

THE HORSE

The form of a horse depends largely on the purpose for which it is used, whether for dray work or riding; the general figure varies accordingly. Unfortunately there are fewer opportunities for studying the characteristics of different kinds of horses now than in the past, as the work formerly done by them has been largely taken over by cars, tractors and other mechanical means. As a rough guide to the proportions of the horse's body it can be seen that the main parts fall within a square, the height being equal to the length. Before attempting to draw a horse's head, study the bones forming the skull and lower jaw. Compare the differences in the bones of the foreleg and hind leg. The lower shoulder bone corresponds with the human forearm, the horse's knee with a man's wrist and the fetlock with the human knuckles. The fetlock in the hind leg is equivalent to the ball of the foot in man. The heel bone which projects at the back of the hock acts with the muscles as a lever to straighten the leg. It is developed in all fast-moving animals and adds to their power of running and jumping.

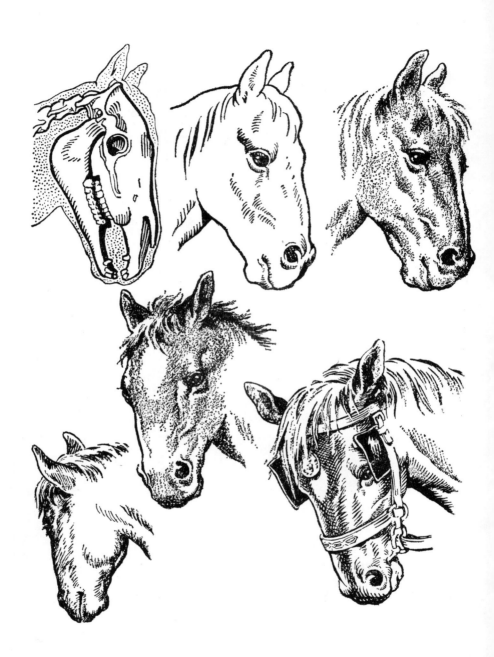

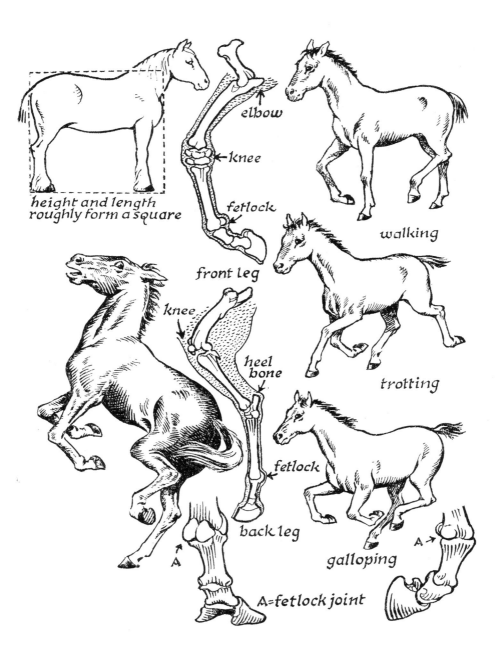

height and length
roughly form a square

elbow

knee

fetlock

front leg

walking

knee

heel
bone

fetlock

back leg

trotting

A

galloping

A

A=fetlock joint

THE COW

Sketch the various animals to be seen in the fields and around a farmyard. A visit to a cattle market or agricultural show will give you plenty of scope for getting close-up studies of farm animals. The skeleton of a cow will help you to understand the framework of the animal. Other drawings on these pages show the position of the ears in relation to the horns, the somewhat mournful expression in the eyes and the formation of front and hind limbs.

THE SHEEP

All farm animals make fascinating models, but perhaps the sheep has less variety and interest than most, especially when its coat is at its fullest. The shape of the body becomes more pronounced after it has been sheared. The facial aspect does not display the changes that most animals assume; a creature of higher intelligence such as a dog can express a variety of moods. His face can show pleasure, fear, anger, caution and affection, whereas a sheep merely exhibits placid indifference except when frightened. Lambs, like all young animals, are full of the joy of life. Their movements emphasize the carefree existence of early days. Watch their frisky gambols as they caper over the grass to join their mother.

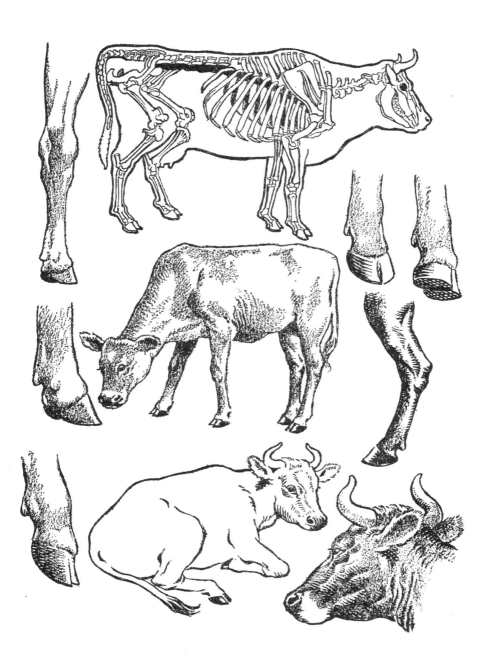

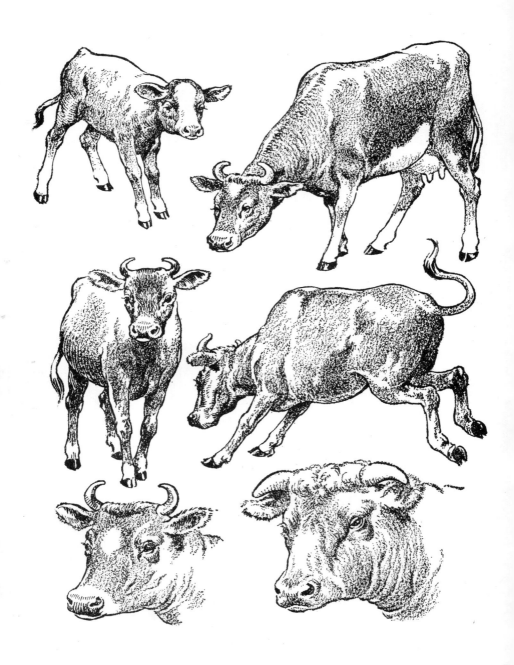

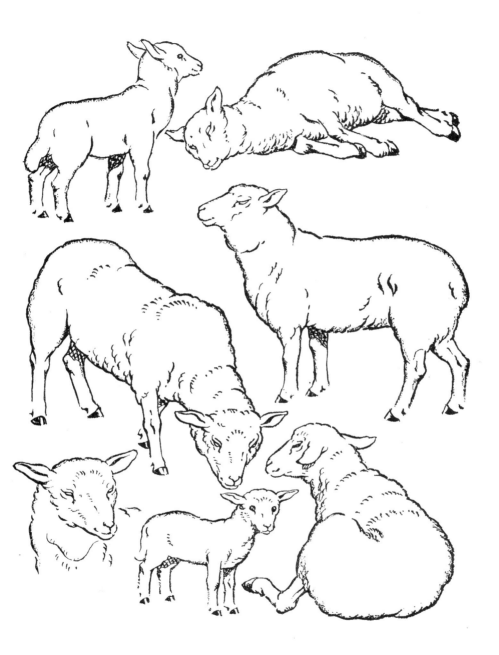

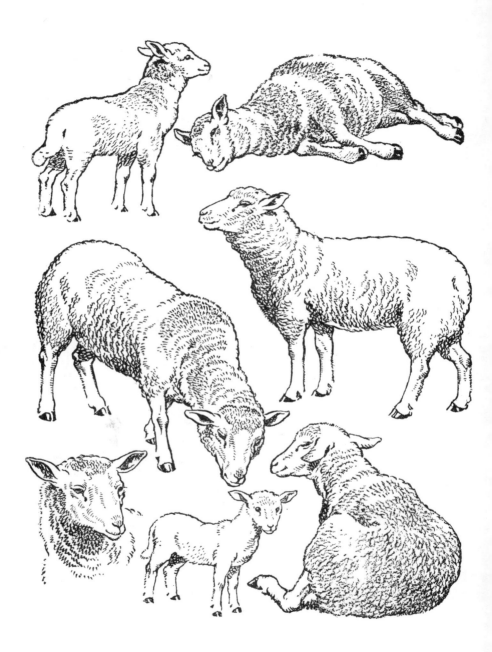

THE PIG

There are very few angles in the make-up of a pig; his body is a mass of curves suggestive of greed and lazy contentment. Unless provoked he makes a steady model, but when agitated the pig can be quite active. He will break into a clumsy run, his sharp eyes fully alert and his pointed ears erect. Try to catch the half-comic expression on his face. A bulky sow surrounded by her litter of noisy youngsters will keep your pencil busy for a long time.

THE GOAT

Goats are less meek and mild than sheep; they are more skittish, erratic, and less inclined to submission, preferring to roam freely. The horns of domesticated goats vary in shape from a backward sword-like curve to a spiral form, according to the breed. The length of hair also varies; in some kinds it is very long; in others it is as short as that of a deer; while the colour can be of any shade from pure white to black or skewbald. The shape of the head differs from that of the sheep, the side view being concave, often with a beard. Try to catch the look of disdain with which the goat watches you.

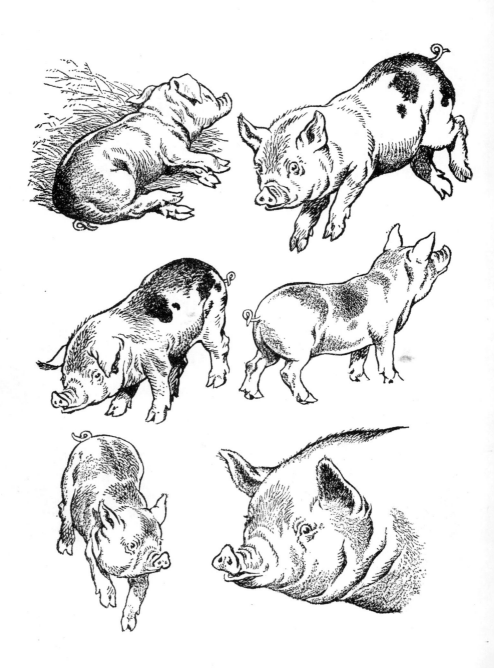

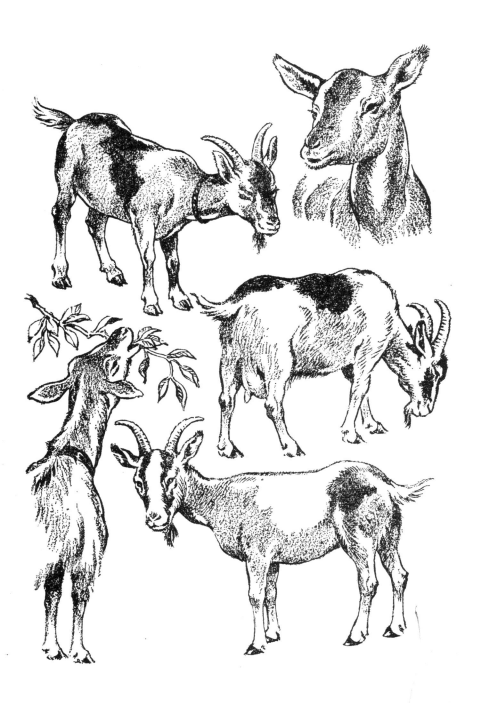

TAIL-END ADVICE

Every walk you take in the country should prove to be full of interest. Your likelihood of success in getting a good view of any of these animals in their own surroundings depends on your manner of approach.

Searching for the creatures of the wild is always fascinating, but bear in mind how shy they are. Unless you move slowly and silently most of them will give you the slip long before you can get more than a fleeting glimpse of the tail end of a vanishing form.

When you *are* lucky enough to catch sight of one, keep perfectly still, with your eyes riveted on your subject. Take in all you can with your mind's eye during the precious moments your quarry is in view; all the detail of shape, movement and features, and, before the impressions have had a chance to fade, jot down in your sketching-book everything you can remember.

Don't allow yourself to be discouraged by what you consider to be your failures.

Every sketch you make will teach you something. Concentrate on the subject; draw it the way you see it, boldly and without faltering. You will reach the state when you automatically gain confidence in your ability to make drawings of animals that even you consider appear to look real.